CHRISTIE'S EDUCATION NEW YORK

3 0000 000928

D1404094

CHRISTIE'S EDUCATION
LIBRARY
Handy
8/6/98

Images

from
the
Machine
Age

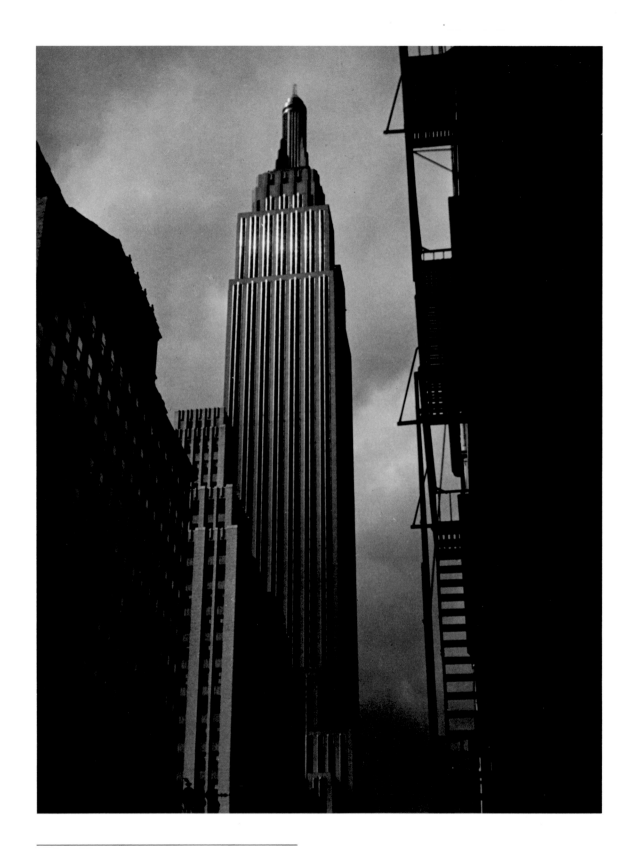

Man Ray (Emmanuel Rudnitsky) AMERICAN, 1890–1976
Empire State Building, 1936 Gelatin silver print

Images from the Machine Age

Selections from the Daniel Cowin Collection

INTERNATIONAL CENTER OF PHOTOGRAPHY

New York | 1997

This catalog is published by the
International Center of Photography, 1130 Fifth Avenue, New York, NY 10128,
in connection with the exhibition
Images of the Machine Age: Selections from the Daniel Cowin Collection,
December 5, 1997 – February 22, 1998.

ISBN 0–933642–25–3

Copyright © 1997 International Center of Photography

We are grateful to the individuals and institutions who have granted us permission to reproduce
the photographs in this volume. Berenice Abbott's photograph appears courtesy of Commerce
Graphics Ltd., Inc.; Brassaï's photograph is © Gilberte Brassaï; Lotte Jacobi's photograph is
© Lotte Jacobi Archive, Dimond Library, University of New Hampshire; Man Ray's photographs
is © 1988 Man Ray Trust, Artists Rights Society, New York/ADAGP, Paris; Charles Pratt's
photograph is © Julie Pratt, and it appears courtesy of Robert Mann Gallery.

The photographs by Jack Delano, Walker Evans, Dorothea Lange, Russell Lee, and John Vachon
were made for the United States Farm Security Administration. They are reproduced courtesy of
the F.S.A., Print and Photography Division, Library of Congress, Washington, D.C.

Printing: The Stinehour Press
Typefaces: Bauer Bodoni and City
Design: Jerry Kelly

COVER: Mannie Lovitch, American, *Out of Mesh*, 1920s, gelatin silver print

Foreword

Daniel Cowin had an eye for quality in artworks of all kinds. He was a lifelong collector whose interests ranged from folk art to Renaissance and 18th-century furniture, 19th-century American painting, Wienerwerkstätte silver, and fabrics. He assembled museum-quality Art Deco rooms, and he patiently silvered pinecones for display in his dining room. Although he was a banker, he did not acquire art as an investment or for status. His joy in collecting was aesthetic and intellectual, and he shared it unostentatiously with his family and friends. Always patient, he would wait until what he coveted became available at a price he approved.

Daniel had an intuitive understanding of photography without having formally studied its history. He was less interested in acquiring the classic icons of 1920s and 1930s photography than in locating remarkable pictures overlooked by other collectors. In this exhibition are works by Berenice Abbott, Brassaï, Walker Evans, Raoul Hausmann, Dorothea Lange and Man Ray, as well as the work of Jaromir Funke, Frantisek Drtikol, and Jaroslav Rossler, collected long before they became well known in this country, and also the gems of advertising photography which were Daniel's particular love. He hunted for and embraced the unrecognized, unusual and underappreciated.

An association with the International Center of Photography in 1983 led to his joining the Board of Trustees in 1987, and he remained an active member until his untimely death in 1992. He was enthusiastically involved in our exhibition and collection programs, often sharing with our curators his latest discoveries. Among his donations is a portfolio by Ansel Adams entitled *The Sierra Club Outing* (1929), containing early pictures made with a small format camera. Another donation is an important collection of photographs and archival material documenting African-American life in the United States from the early 1850s through the mid-1950s. This group of more than 3,000 items is a unique resource emphasizing middle-class experience as seen through family albums and snapshots. ICP has mounted two exhibitions from this collection, which has drawn the interest of many historians and curators.

It is a special privilege to be able to present a selection of works from Daniel Cowin's modernist photographic collection in the form of the exhibition *Images from the Machine Age*. I want to extend our thanks to Joyce Cowin, who has worked diligently to preserve her husband's collections, and to their children Kenneth, Andrew and particularly Dana Cowin, whose participation in the exhibition

has been invaluable. I would also like to thank Ellen Handy, ICP's Associate Curator, who made this selection from thousands of works in the collection, and Miles Barth, ICP's Curator of Archives and Collections, who more than any of our staff had the pleasure of working with Daniel Cowin.

Willis Hartshorn
Director

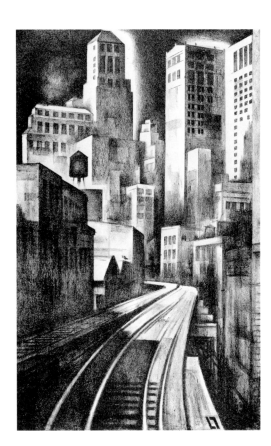

Louis Lozowick, AMERICAN, BORN IN LUDINOVKA, RUSSIA (NOW IN UKRAINE), 1892–1973
Third Avenue, 1930
Lithograph

Images from the Machine Age:
Photography, Advertising and the Symbols of Modernity

"Machine Age" has become one of the familiar labels we use in denominating historical moments, a kind of shorthand generally understood to refer to the 1920s and 1930s, or perhaps a few years more on either side. Falling roughly between what in America was known as the Gilded Era (in Europe, the Belle Epoque) and the Space Age, Machine Age is a designation that overlaps many others also in use for the same period or for specific aspects of its culture. The inter-war years, the Jazz Age, the Roaring Twenties and the Great Depression all fall into this chronological span, as do the numerous artistic and literary movements such as Cubism, Surrealism, Constructivism and Art Deco, an applied arts style. During this period industry and the sudden popularity of the automobile and radio were among the constituent elements of modernity, and machinery was associated with progress, enlightenment and science. As Henry Ford put it, "Machinery is accomplishing in the world what man has failed to do by preaching, propaganda or the written word."[1] This embrace of machinery as the defining principle of twentieth-century life characterizes not just the 1920s and 30s, but also the following two decades, finding its culmination in the industrial design of the 1940s and 50s.[2]

The works in this exhibition were selected from the Daniel Cowin Collection of photographs, drawings, prints, paintings, sculpture and *objets d'art*. (Non-photographic works from the collection are reproduced as figures in the text while photographs appear as plates following it.) As a collector, Daniel Cowin was a man of great individuality. His collection is witty, unexpected, idiosyncratic and richly informative about the diverse culture of the Machine Age in Europe and America. It demonstrates many of the most important issues in photography during the period, often through the inclusion of works not yet particularly well known.

In this collection, special emphasis is placed on the work of Eastern European and German photographers, with a clear preference for commercial and amateur photography over works of self-proclaimed artists. Art history usually tells the story of a period as complex as this one through the work of those who come to be considered canonical artists, emphasizing their activity as central, while that of those whom they influenced is considered peripheral. Rejecting this model, the Cowin Collection surveys the period by emphasizing its characteristic eclecticism, innovation and refusal to distinguish between professional and amateur, art and advertising, avant garde and popular work. Cowin's inde-

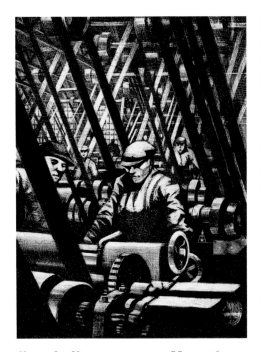

Christopher Nevinson, BRITISH, 1889–1946
Making the Engine, 1917
Lithograph

pendence and democracy of taste led him to build a collection of modernist photography which, while omitting many familiar names, such as Paul Strand, Edward Weston, László Moholy-Nagy and André Kertész, includes the work of William Rittase, John Havinden, Wynn Richards and many others who are just beginning to be appreciated by collectors and scholars. All of the works selected from the Cowin Collection for this exhibition represent aspects of the new imagery of the Machine Age.[3]

In the iconography of the first half of the twentieth century, machines and factories are the outward and visible signs of a force that was making itself felt at every level in society. The cover of this book reproduces *Out of Mesh*, a work by the amateur photographer Mannie Lovitch. It is a close view of some colossal gears, an image of curiously ambiguous attitude toward the ubiquity and power of the machine. More characteristic of the period are other works in the exhibition, such as Rittase's *St. Joseph Lead Company* and Else Thalemann's *Machine Detail*, and several photographs by Albert Renger-Patzsch, all of which depict machinery or machine-made forms with keen admiration. In this collection, the comfortable mingling of the government-supported illustrative documentary art of the Works Progress Administration and the Farm Security Administration artists with that of Bauhaus and Surrealist artists is quite unexpected. Yet images of machines and Machine Age cities are typical of various European avant garde styles and the American Precisionism of the 1920s, as well as of the aesthetically more conservative styles of the same period.[4] In all, repetition, geometry and machine forms serve as metaphors for modernity, which is construed as an industrial, mechanical condition.

Machine imagery extends beyond reverent depictions of factories and the mechanical devices they

contain to the city itself, especially the new cities of towering skyscrapers and rapid movement.[5] Workers in the streets of New York no less than factory hands on the production line were representatives of modernity, capitalism and the new order of the machine. While Man Ray isolated the ultimate Machine Age architectural form, the Empire State Building, in a composition framed from street level, Berenice Abbott ascended its towering summit at night to survey the glittering city. Her photograph proclaims that it is the city, and not the single house, as Le Corbusier announced, that is a machine for living and working in.[6] In Arnold Eagle's laterally reversed print, the Chrysler Building—another icon of the New York skyline—springs from the elevated train tracks in the foreground.

In the modern city, transportation is essential—the buildings stand still but everything else moves quickly. T. Lux Feininger's view from ground level makes this point, but suggests that cars, not human individuals, are the basic unit of the city's dynamic population. Modernity was not solely an American phenomenon: Brassaï's Parisian street scene is animated to a fever pitch of vitality by lights and traffic. But life did move faster in New York than anywhere else. Charles Pratt's photograph of crowds disembarking from the Hoboken ferry at rush hour captures this pulsing rush of humanity in the Machine Age city, while Herbert Bayer's sky view represents the city as a blank canvas upon which advertisements, the central aphorisms of modernity and industry, are inscribed by an airborne machine.

In addition to its elements of rational pragmatism, the Machine Age city contained the dusk, drama and mystery evident in Herbert List's *Rue de Rivoli, Paris*. Frantisek Drtikol's untitled study of figures on a staircase and Edmund Teske's *Chicago [Mannequins]* both seem to belong to a de Chirico-like world of shadowy adventure. In twentieth-century cities, mass consumption, anonymity, brilliant illumination and commodified recreation—all of which had been marvels of Second Empire Paris, the first modern city—were naturalized, and became the sine qua non of modernity around the world, rather than the exceptional attributes of a single capital.

Like the skyscraper cities, the business of entertainment came to be regarded as a consequence of Machine Age prosperity, and one of its hallmarks.[7] The new mechanized forms of recreation (such as films rather than vaudeville performances) dramatized the ways in which industry shaped culture. Workers and machine operators took on the roles of consumers as well as producers in society, but they

could at any moment be reduced to unemployment, as was cruelly demonstrated during the Great Depression following the stock market crash of 1929. Lotte Jacobi's photograph of Russian workers and Dorothea Lange's of unemployed men in San Francisco represent two sides of the same coin.

Despite the hard times, mass media established itself in America to an unprecedented degree, and rural as well as urban residents could participate as its consumers. While only the glitterati attended the elegant premieres of new films in Hollywood like the one pictured in *Douglas Fairbanks Film Premiere, Grauman's Chinese Theater, Hollywood*, every small-town cinema in America would soon show the same movie to a less exclusive audience. Music, comedy and news went out by radio around the clock and around the world, reaching even the most remote of listeners, like the woman in Russell Lee's *North Dakota Farm Woman Listening to Radio*. City streets were plastered with placards announcing new films and other entertainments, as Ilse Bing's *Poster for "The Private Life of Henry VIII," Paris* and Walker Evans's many photographs of movie and other posters demonstrate.

Newspapers and picture magazines like *LIFE, Picture Post* and *Vu* were no less important media outlets, and they were the natural home of what was already becoming the most powerful form of imagery and communication of all: advertising. The 1920s saw the rise of advertising as we know it today, and photography was central to its development. Advertising is the white collar manifestation of the Machine Age, set into motion by the operations of heavy industry. Its apparently unmechanized productions are in fact the ultimate and logical outcome of the capitalism and free enterprise which produced the Machine Age. Advertising's creation of desire animated the new consumerism that characterized a society of worker-purchasers.

The stylish, boldly illuminated, sometimes abstracted compositions which came to typify advertising photography were well suited to the regular, crisp, geometric forms of machine-made commodities, whether hats photographed by Aubrey Bodine, cups and saucers arranged by Josef Sudek, or a group of flashily labeled bottles of milk composed by Edward Quigley. As advertising photographs became ubiquitous, they began to turn up as subject matter in documentary photographs. One such example by John Vachon of a chance juxtaposition of fragments from advertising posters seems to predict the imagery of Willem de Kooning's *Women* of the 1950s, or even the work of the Pop artists who followed in the next decade.

Advertising design and photography were immediately responsive to the abstraction of European modernism. Many scholars have emphasized the ways in which the earliest examples of American photographic abstraction derive from the influence of Cubism, particularly in the case of the many pupils of the Clarence H. White School of Photography, where fine art and commercial photography were taught together with a common emphasis on abstract design.[8] But in the 1920s and 30s the styles of other European art movements also crossed the Atlantic and helped to shape the common idioms of American photographic practice. Of these, the Bauhaus's influence was particularly significant, in part because of its actual relocation in 1937 from Germany to Chicago. Its entire curriculum and philosophy were transplanted along with charismatic teachers like Moholy-Nagy. In comparison, the influence of the simultaneous arrival in America of the Surrealist diaspora was much weaker, perhaps because it was dissipated by the Surrealists' own anarchic tendencies.

At the Bauhaus, architecture was central to all design, arts were practiced in partnership, and design demanded an alliance of abstraction and pragmatism. A photograph by Bauhaus student Walter Tralau, *Assignment for László Moholy-Nagy's Preliminary Course*, can serve to represent the Bauhaus's commitment to this architectonic aesthetic. Students in Moholy-Nagy's first-year course made abstract sculptural constructions, and then rendered them two-dimensional through photography. This photograph is both a document of Bauhaus classroom practice and a use of sculpture to generate abstract photographic imagery.

Ultimately, the Bauhaus's greatest legacy in America was not so much its architecture-based functionalism as its emphasis upon experimentation, typified by the enthusiasm for abstract camera-less photographs, or photograms. Arthur Siegel, who studied at the Illinois Institute of Design

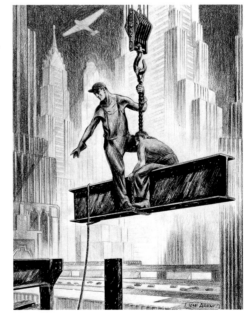

Herschel Levit, AMERICAN, 1912–1986
Take It Away!, 1940 Lithograph

(as the American Bauhaus came to be known) and later became the head of its photography program, made the photogram reproduced in this book while still a student. He perpetuated Bauhaus ideas into the later years of the Machine Age and beyond.[9] Another aspect of the Bauhaus spirit of improvisation was the encouragement of all its members to experiment with photography. Many of the photographs included in this exhibition are the work of individuals not primarily identified as photographers. Georg Trump, for example, was a typographer whose typeface "City" is used for the titles in this book.

Trump's *Orange and Shadow* makes of nature an abstraction, using a very different approach than that of Siegel's photogram. Its quintessentially European graphic style is equally suitable for fine art or commercial photography. Many of the American fine art photographers of this period, like Weston, rejected the commercial applications of the medium, preferring to record natural subjects with an almost transcendentalist fervor for nature, art and photography. Trump's photograph and Josef Ehm's *Cacti and Rocks* reveal the wide influence of the *Neue Sachlichkeit* (New Objectivity) movement's love of sharp, highly detailed imagery,

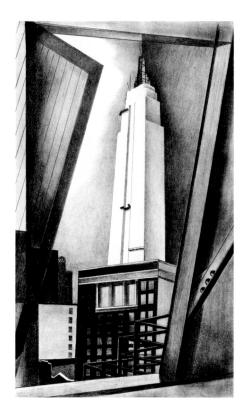

Ernest Fiene, AMERICAN, 1894–1966
Empire State Building, 1930 Lithograph

which is epitomized by Renger-Patzsch's classic 1928 book *Die Welt Ist Schön* (The World Is Beautiful). Trump's orange and Ehm's cacti demonstrate that even when depicting natural objects rather than dynamos or turbines, photographers could bring a Machine Age sensibility to their work.

Regardless of its subject, photography was understood to be the true machine art, the most authentically modern medium available. In 1926, Moholy-Nagy wrote that "it is irrelevant whether an

artist employs three-dimensional, linear, pictorial, black and white, colored, photographic, or other means to represent something. But today it has become almost natural to favor a representation done by mechanical means, with all its consequences, over a painstaking, manually executed visual representation . . . In this competition the photographic process will win out."[10] Photography was available to serve all agendas. Itself a modern method of picture-making, it was also capable of reflecting design themes pioneered in other media. One property of photography that was used to great effect was the close-up, which made ordinary objects dramatic through cropping. Detail was thus a means to abstraction, a sign of photography's identity as a modern machine-art, a tool of realist scrutiny and a striking graphic device. Images like Havinden's *Fire Escape*, Richards's *Matches* and Renger-Patzsch's *Detail [grater]* rendered the surfaces of the world as regular, almost mechanical forms.

If on the whole the European Machine Age sensibility was more open and flexible than the sometimes dogmatic moralism concerning fine art photography in America, there was nonetheless an enthusiastic embrace of European modernist design idioms by many Americans, particularly those working in commercial photography. An advertising photograph by John Collins, *Bausch and Lomb Binoculars*, depicts an instrument of vision that is emblematic of what Moholy-Nagy and the other Bauhaus artists always called "the new vision," a truly modern way of seeing. This stylized still life of binoculars and their shadow represents one pole of Machine Age aesthetics, while Henryk Hermanowicz's *Woman with Closed Eyes*, a Surrealist-inspired revelation of the dreamy interiority of the individual, represents the other. The visions of the Machine Age were directed both outward to the products and objects of external reality, and inward to the subjective aspects of modern experience.

Ellen Handy
Associate Curator

NOTES

14

1. Henry Ford, "Machinery, the New Messiah," *The Forum* 79 (March 1928), p. 363.

2. Richard Guy Wilson, Dianne H. Pilgrim and Dickran Tashjian, *The Machine Age in America 1918–1941*, New York: The Brooklyn Museum, 1986. This broad and insightful treatment of the period has greatly influenced all subsequent work on the topic. The continuity between machine idolatry in the 1920s and subsequent industrial (particularly automotive) design is a point which has been made emphatically by Robert Hughes, in his recent book *American Visions: The Epic History of Art in America*, New York: Alfred A. Knopf, 1997.

3. The most important study of modernist photography to date is an exhibition catalog by Maria Morris Hambourg and Christopher Phillips, *The New Vision: Photography Between the World Wars*, New York: The Metropolitan Museum of Art, 1989. This volume includes the work of the most celebrated photographers of the period.

4. Gail Stavitsky, ed., *Reordering Reality: American Precisionism*, New York: Harry N. Abrams, 1994.

5. Miles Orvell, *After the Machine*, University of Mississippi Press, 1995.

6. Le Corbusier, *Toward a New Architecture* (1923), translated by Frederick Etchells, London: John Rodker, 1931, reprinted New York: Dover, 1986, p. 4.

7. Ann Douglas, *Terrible Honesty: Mongrel Manhattan in the 1920s*, New York: Farrar, Straus and Giroux, 1995.

8. John Pultz and Catherine B. Scallen, *Cubism and American Photography*, Williamstown, MA: Sterling and Francine Clark Art Institute, 1981 and *Pictorialism Into Modernism: The Clarence H. White School of Photography*, edited by Marianne Fulton with text by Bonnie Yochelson and Kathleen A. Erwin, New York: George Eastman House in association with the Detroit Institute of Arts, 1996.

9. Charles Traub, ed., *The New Vision: Forty Years of Photography at the Institute of Design*, New York: Aperture, 1982.

10. László Moholy-Nagy, "'Isms' or Art," *Vivos Voco* (Leipzig), vol. V, no. 8/9, August/September 1926, quoted in Hans M. Wingler, *The Bauhaus*, Cambridge, MA: MIT Press, 1978, p. 115.

Plates

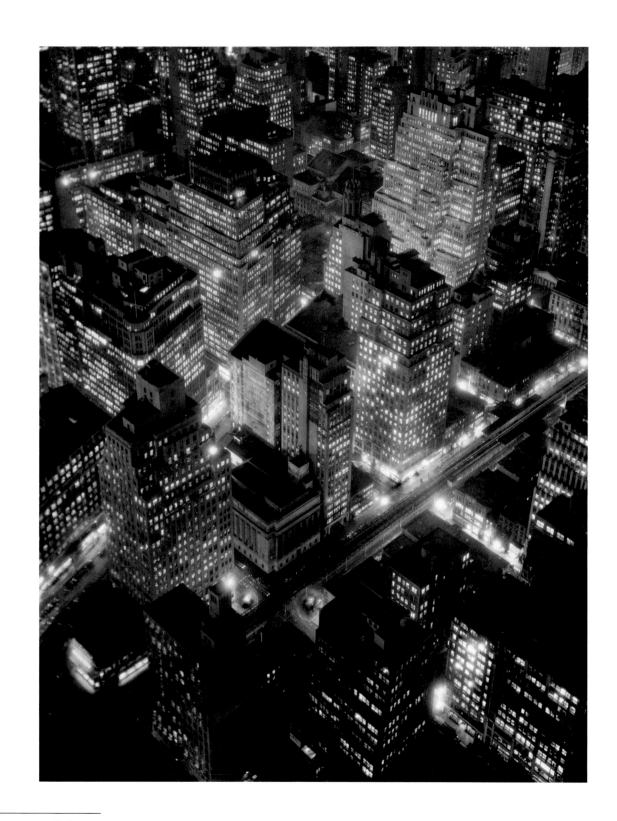

Berenice Abbott AMERICAN, 1898–1991
New York at Night, Empire State Building, 350 Fifth Avenue, West Side, 34th and 33rd Streets (General View North), Manhattan, c. 1932
Gelatin silver print

Arnold Eagle AMERICAN, 1909–1992
New York [skyline and El tracks], 1935 Gelatin silver print

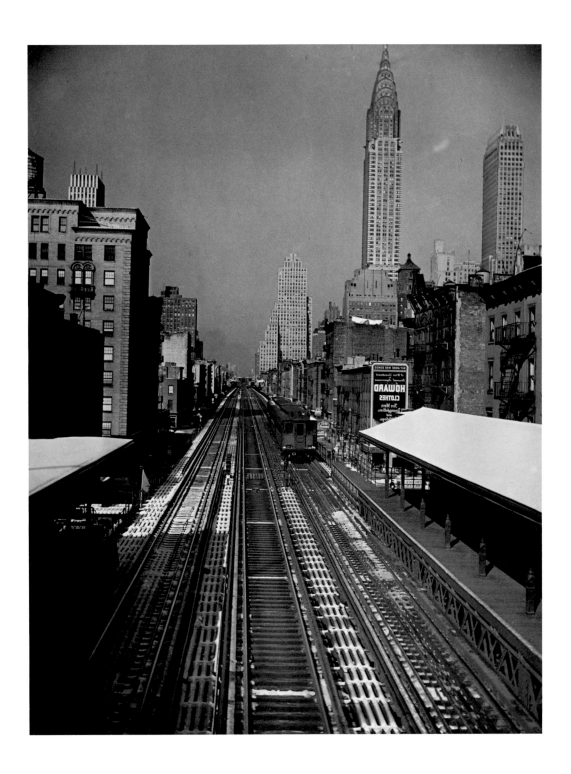

T. Lux Feininger AMERICAN, BORN IN GERMANY, 1910
New York, 1948 Gelatin silver print

Brassaï (Gyula Halàsz) FRENCH, BORN IN BRASOV, TRANSYLVANIA (NOW IN ROMANIA), 1899–1984
Street Scene, Paris, 1930–1939 Gelatin silver print

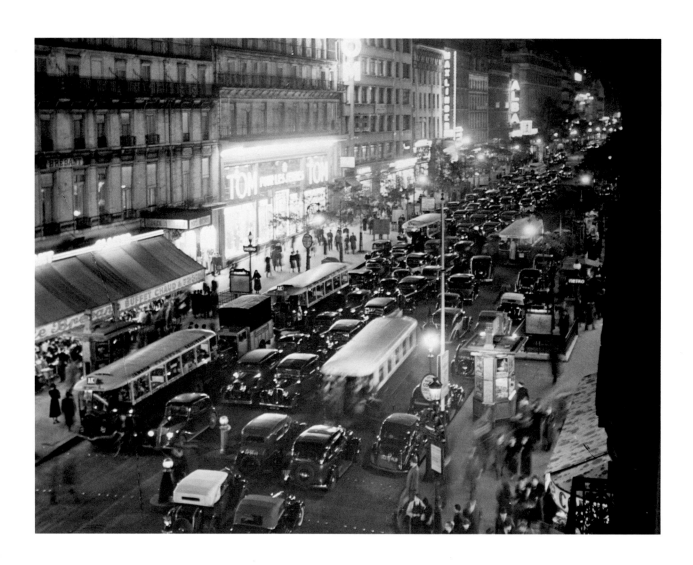

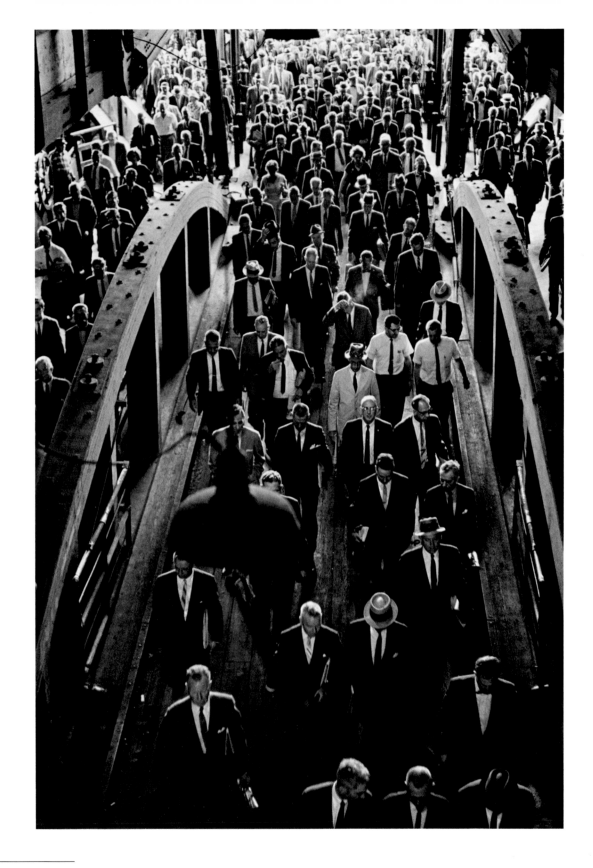

Charles Pratt AMERICAN, 1926–1976
Hoboken Ferry, 1955 Gelatin silver print

Lloyd Yost AMERICAN, ACTIVE 1920S–1930S
The First Day Club, 1930 or earlier Gelatin silver print

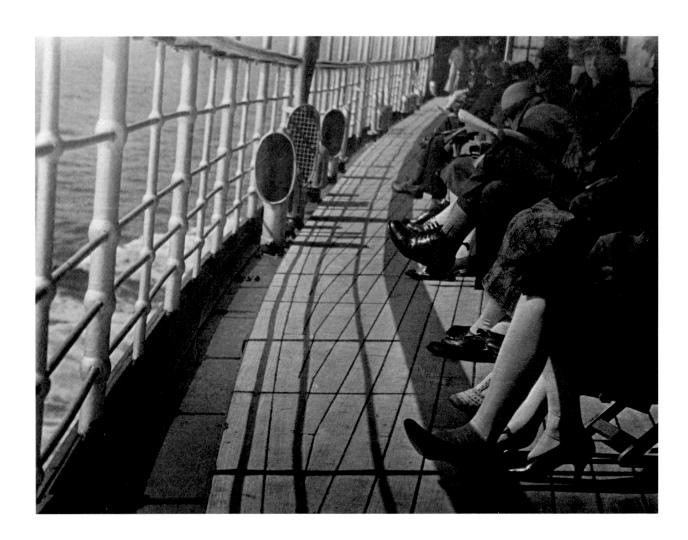

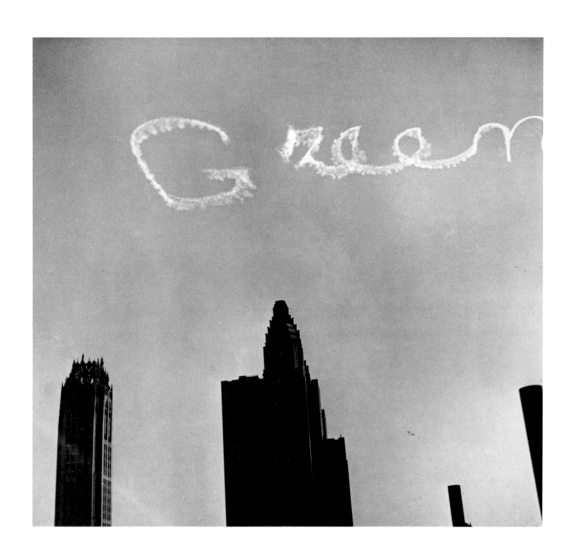

Herbert Bayer AMERICAN, BORN IN AUSTRIA, 1900–1986

[New York City, skywriter], 1937 Gelatin silver print

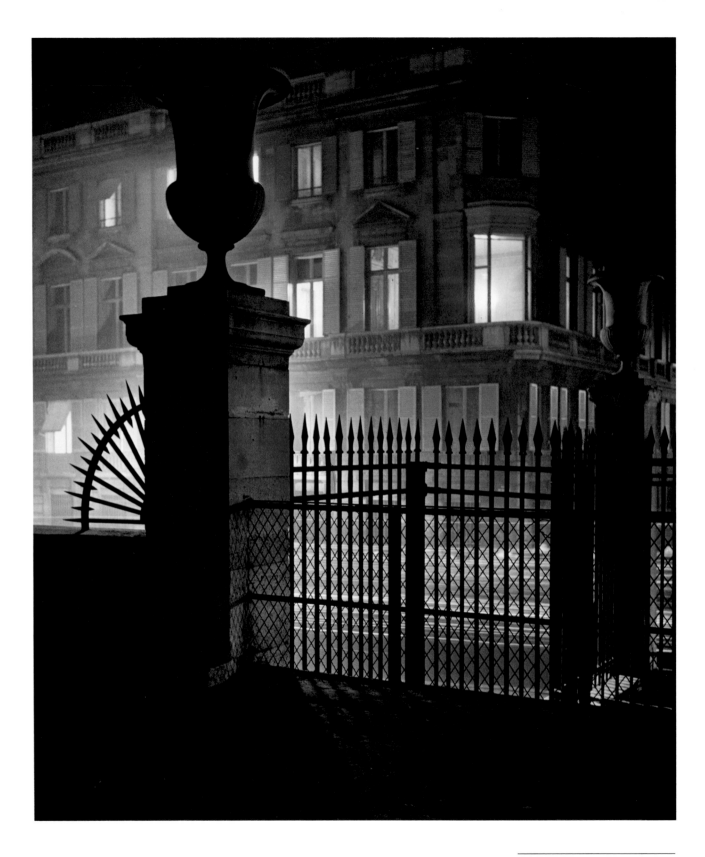

Herbert List GERMAN, 1903–1975
Rue de Rivoli, Paris, 1936 or later Gelatin silver print

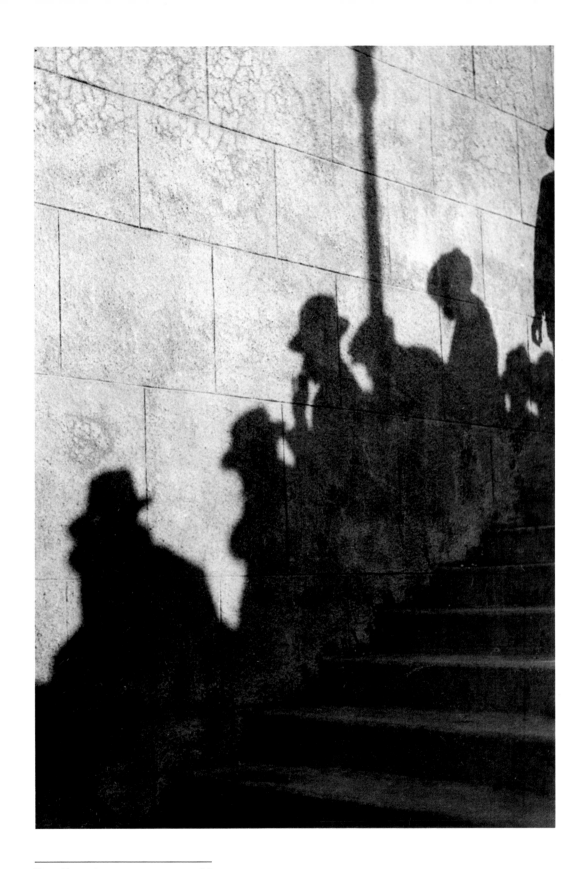

Hans Casparius GERMAN, 1900–1986
Untitled [Shadows on steps], c. 1930 Gelatin silver print

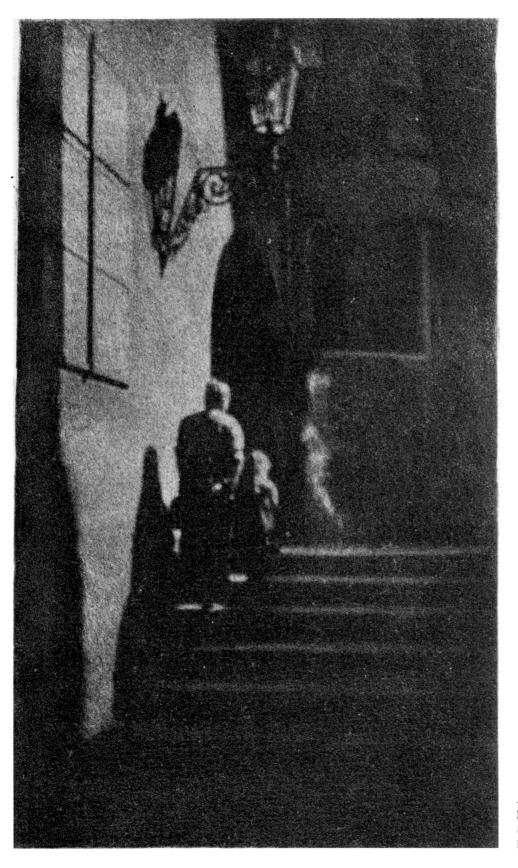

Frantisek Drtikol CZECH, 1883–1961
Untitled [Figures on a staircase], 1911
Pigment print

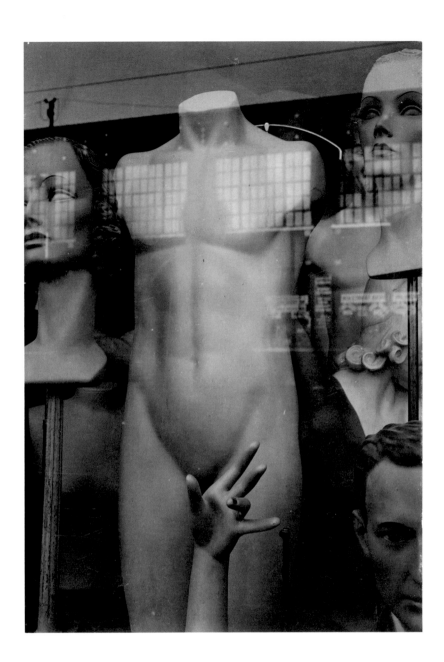

Edmund Teske AMERICAN, 1911–1995
Chicago [Mannequins], 1938 Gelatin silver print

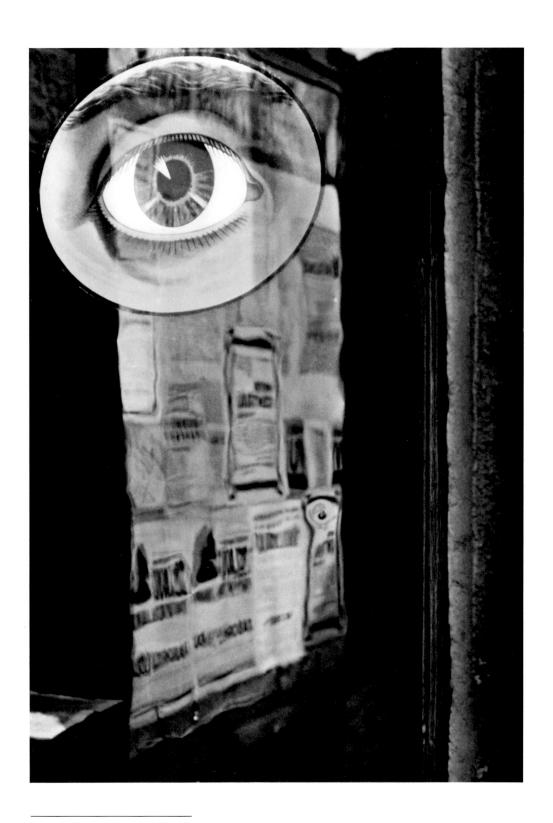

Jaromir Funke CZECH, 1896–1945
From the Cycle "Time Persists," 1932 Gelatin silver print

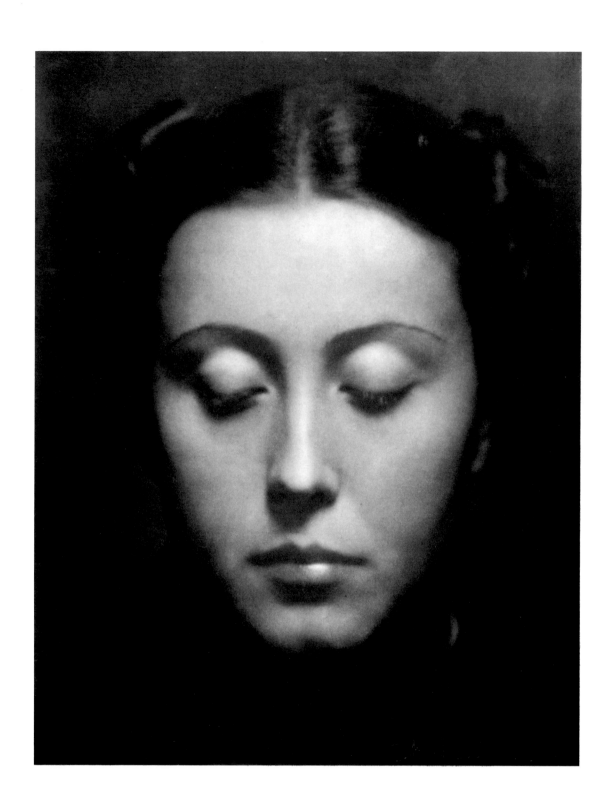

Henryk Hermanowicz POLISH, BORN 1912
Woman with Closed Eyes, 1937 Gelatin silver print

Josef Ehm CZECH,
1909–1989
Cacti and Rocks,
1934–1946
Gelatin silver print

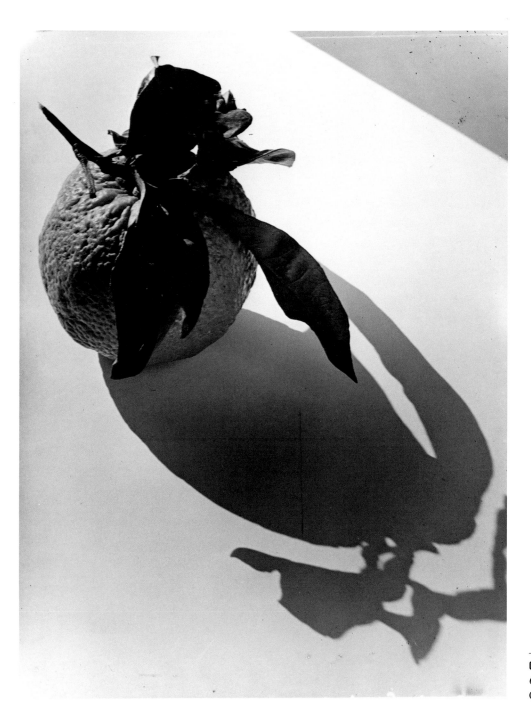

Georg Trump GERMAN, 1896–1985
Orange and Shadow, 1926–1931
Gelatin silver print

Wynn Richards (Martha Wynn) AMERICAN, 1888–1960
Matches, c. 1922 Gelatin silver print

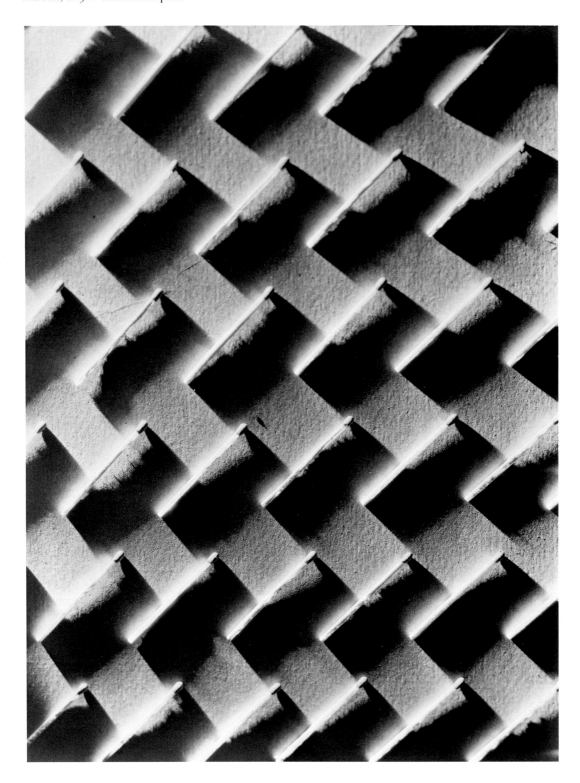

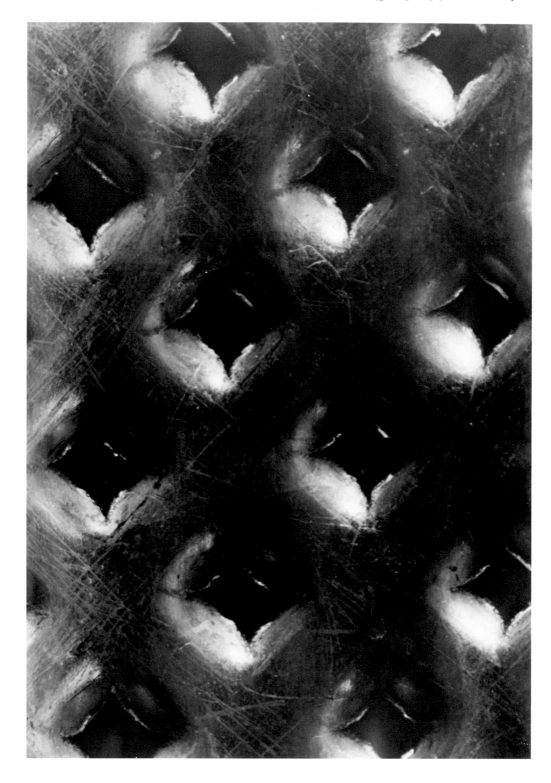

Hans Bellmer FRENCH, BORN IN KATOWICE, SILESIA (NOW IN POLAND), 1902–1975
The Doll, 1934 Gelatin silver print with paint

Walter Tralau
GERMAN, BAUHAUS
STUDENT DURING
THE 1920S
*Assignment for László
Moholy-Nagy's
Preliminary Course
at the Bauhaus,*
c. 1926–1927
Gelatin silver print

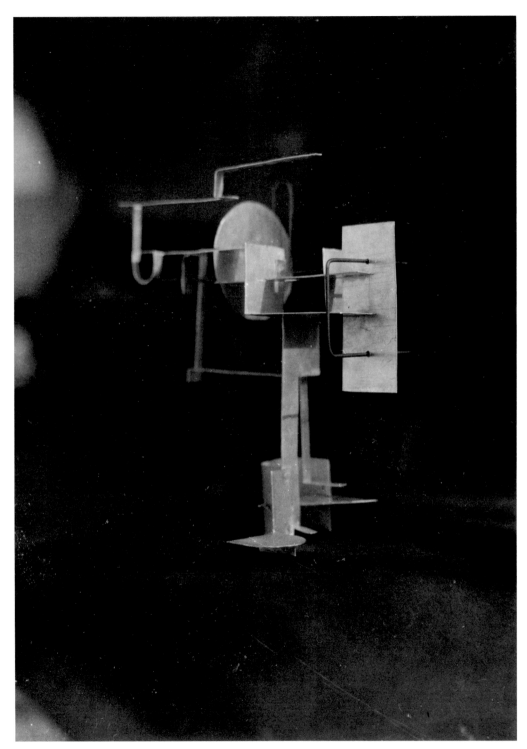

Raoul Hausmann FRENCH, BORN IN AUSTRIA, 1886–1971
Photogram, 1931 Gelatin silver print

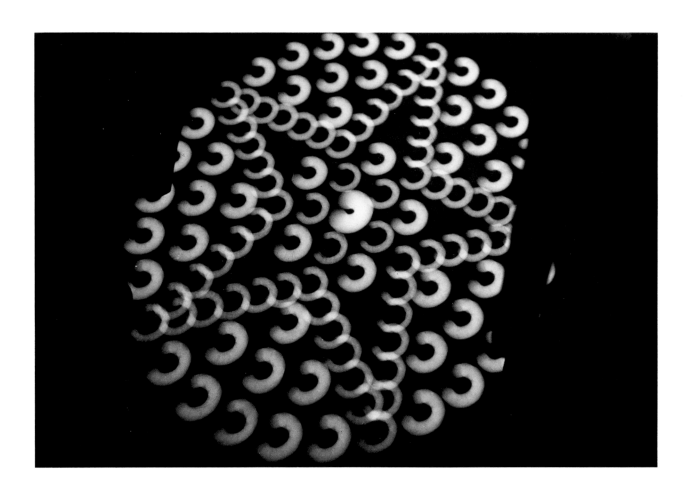

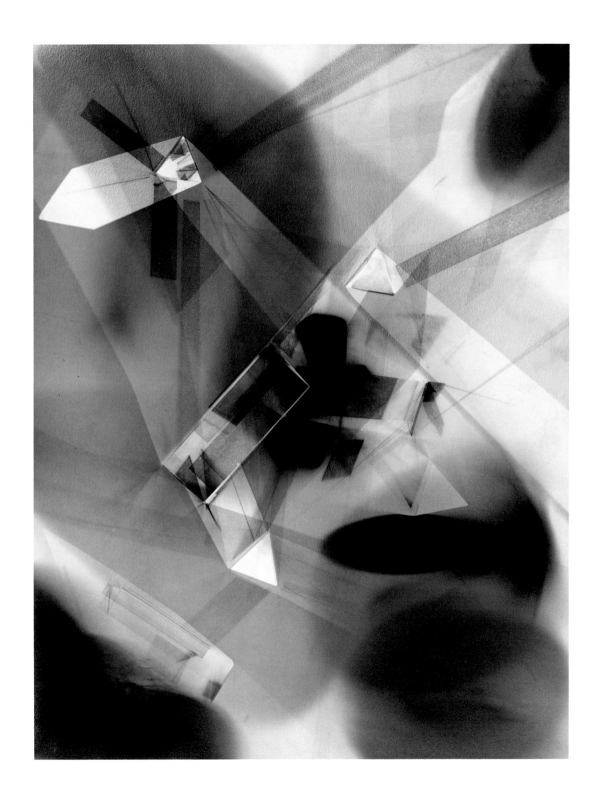

Arthur Siegel AMERICAN, 1913–1978
Photogram, 1937 Gelatin silver print

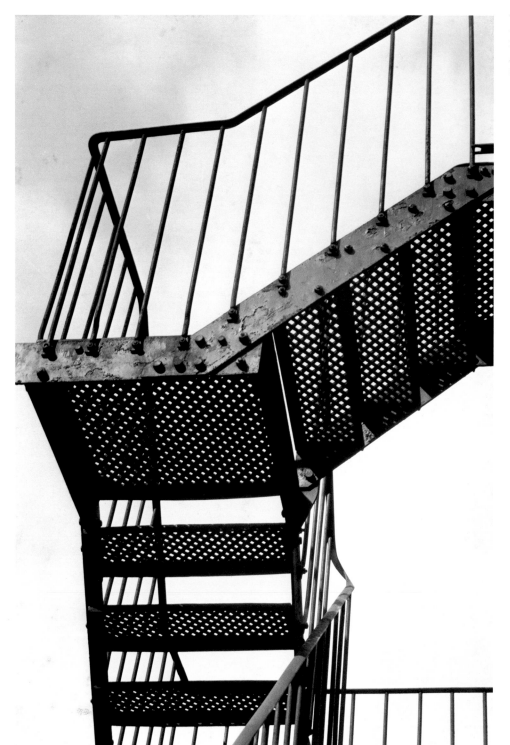

John Havinden BRITISH,
1908–1957
Fire Escape, 1932–1939
Gelatin silver print

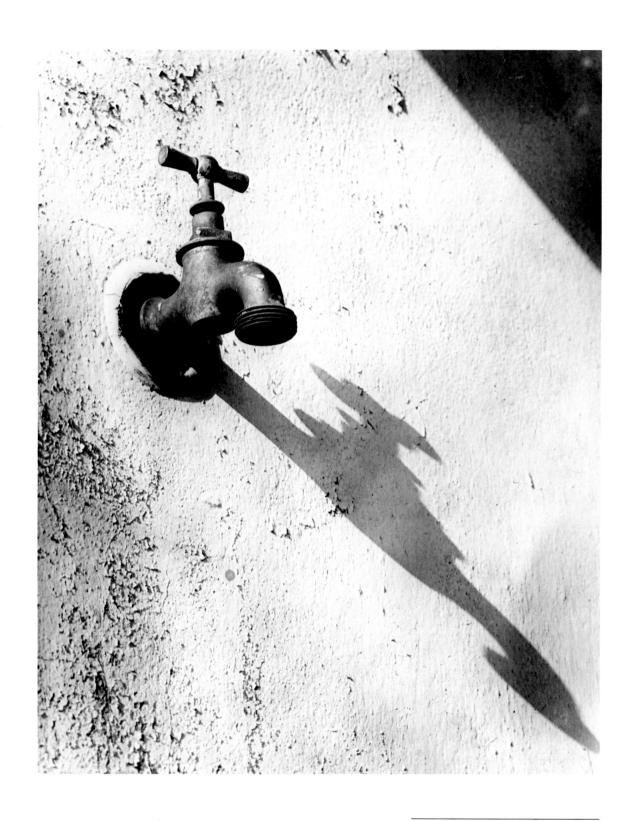

Werner David Feist GERMAN, BORN 1909
Water Tap on Bauhaus Wall, Dessau, 1929 Gelatin silver print

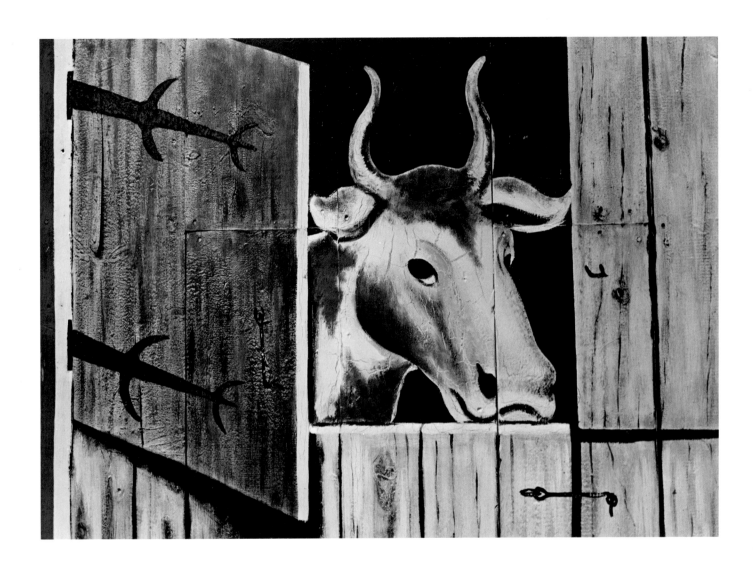

Jack Delano AMERICAN, BORN IN RUSSIA, 1914

Painting on a Barn near Thomasonville, along Route 5, Connecticut, 1940 Gelatin silver print

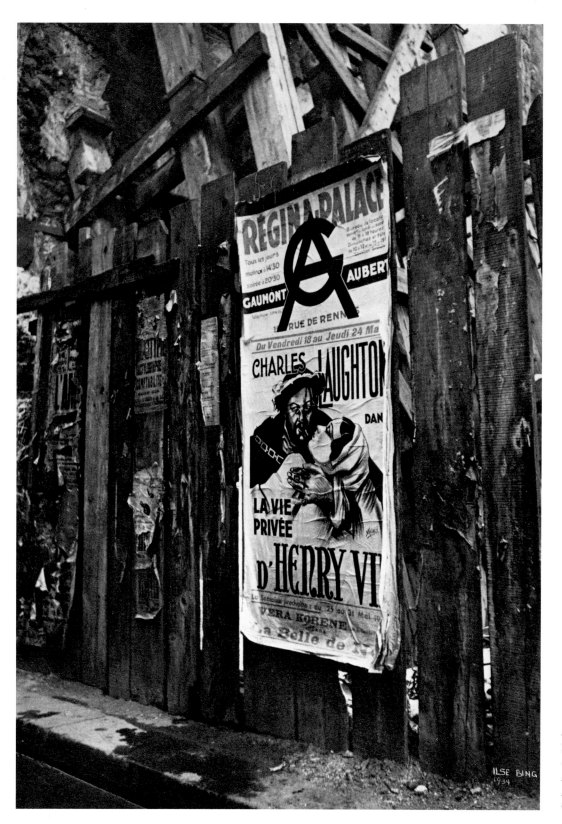

Ilse Bing AMERICAN, BORN IN
GERMANY, 1899
*Poster for "The Private Life of
Henry VIII", Paris,* 1934
Gelatin silver print

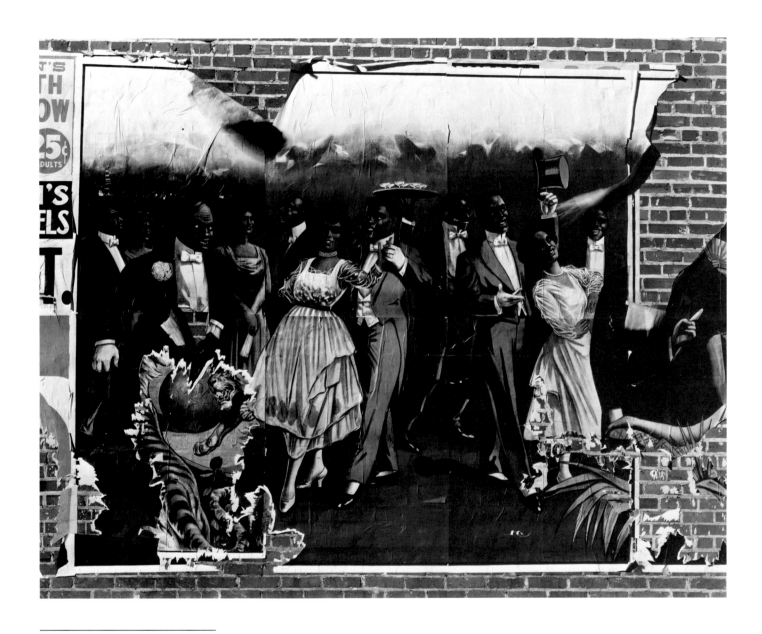

Walker Evans AMERICAN, 1903–1975
Torn Minstrel Poster, Demopolis, Alabama, 1936 Gelatin silver print

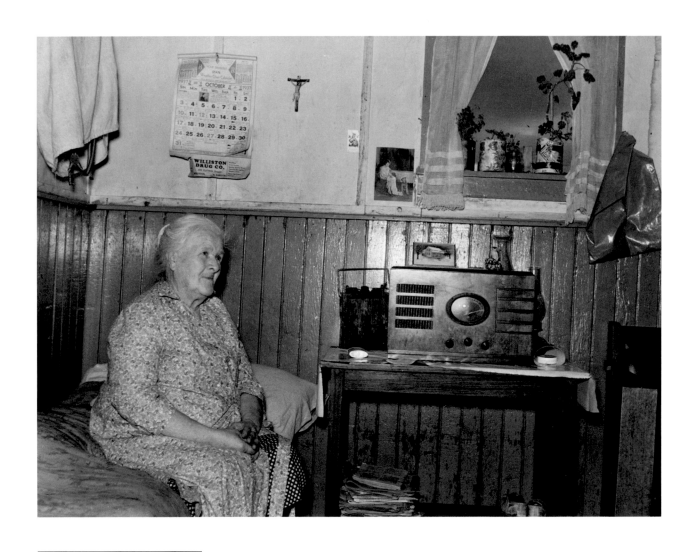

Russell Lee AMERICAN, 1903–1986
North Dakota Farm Woman Listening to Radio, c. 1937 Gelatin silver print

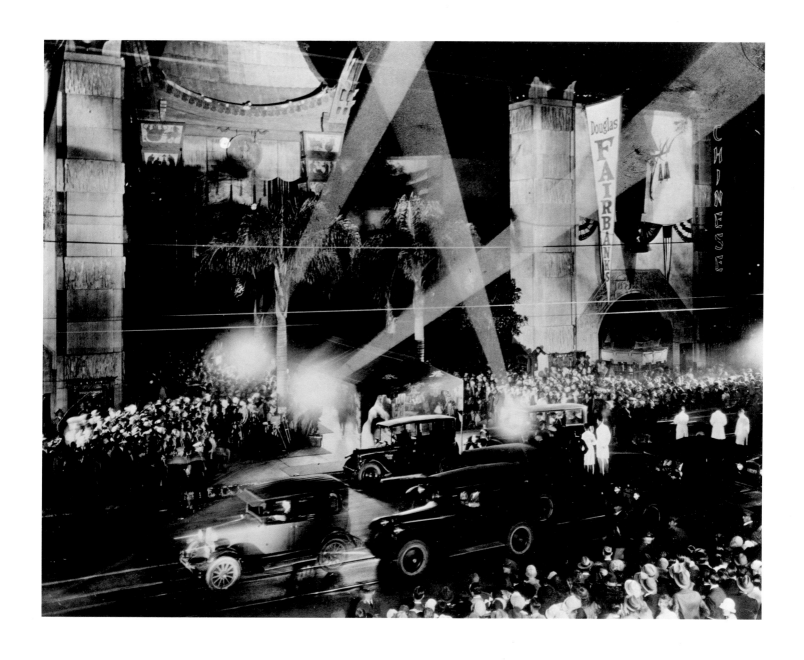

Unidentified
Douglas Fairbanks Film Premiere, Grauman's Chinese Theater, Hollywood, 1928 or 1929 Gelatin silver print

John Vachon AMERICAN, 1914–1975
Advertising, Woodbine, Iowa, 1940 Gelatin silver print

Dorothea Lange AMERICAN, 1895–1965

Unemployment Benefits Aid Begins. Line of Men inside Division Office of State Employment Service Office, San Francisco, 1938 Gelatin silver print

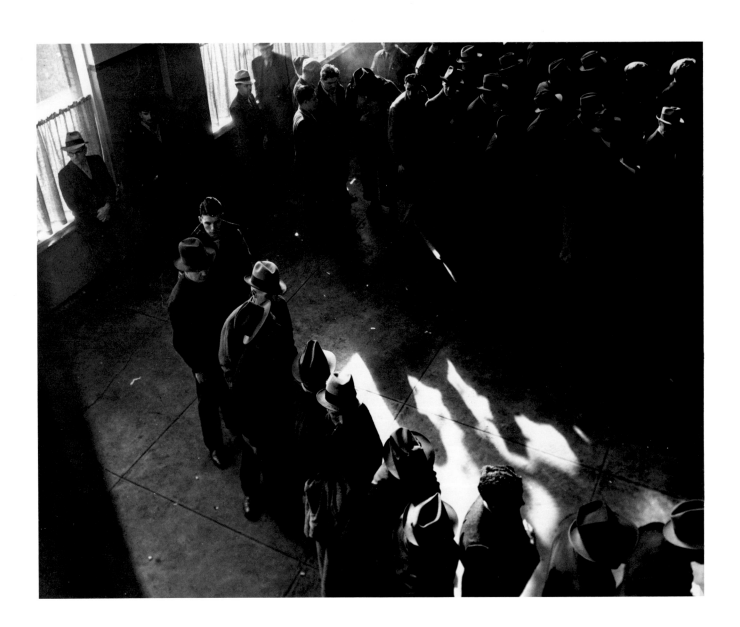

Lotte Jacobi AMERICAN, BORN IN GERMANY, 1896–1990
Russian Workers, 1932–1933 Gelatin silver print

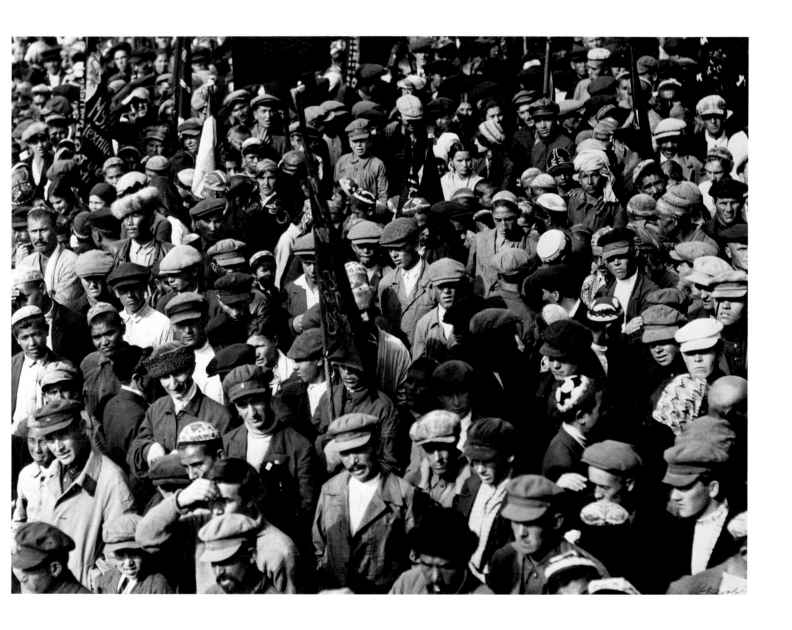

William Rittase AMERICAN, 1887–1968
St. Joseph Lead Company, c. 1940 Gelatin silver print

Else Thalemann GERMAN, 1901–1984
Machine Detail, c. 1930 Gelatin silver print

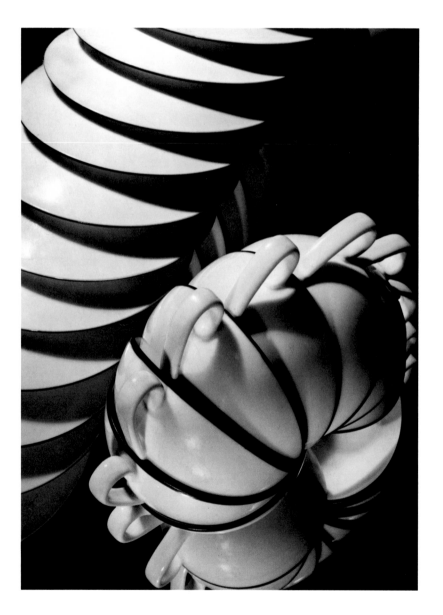

Josef Sudek CZECH, 1896–1976
Cups and Saucers, 1928-1936
Gelatin silver print

A. Aubrey Bodine AMERICAN,
1906–1970
Hats, 1923–1927 Gelatin silver print

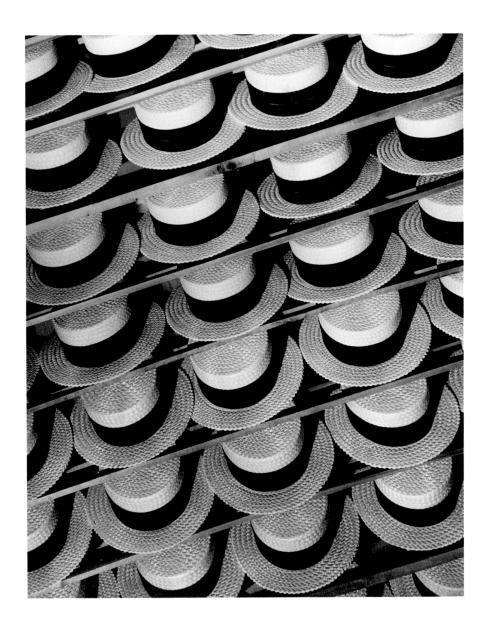

Henry Flannery AMERICAN, ACTIVE 1930S
Backgammon, c. 1930 Gelatin silver print

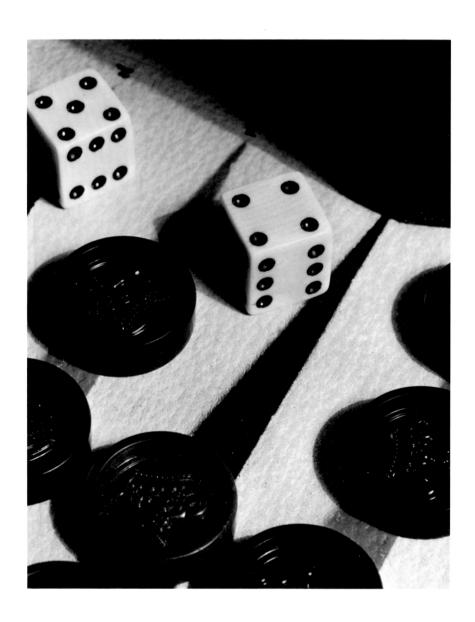

Edward Quigley AMERICAN, 1898–1977
Milk on Ice, c. 1930 Gelatin silver print

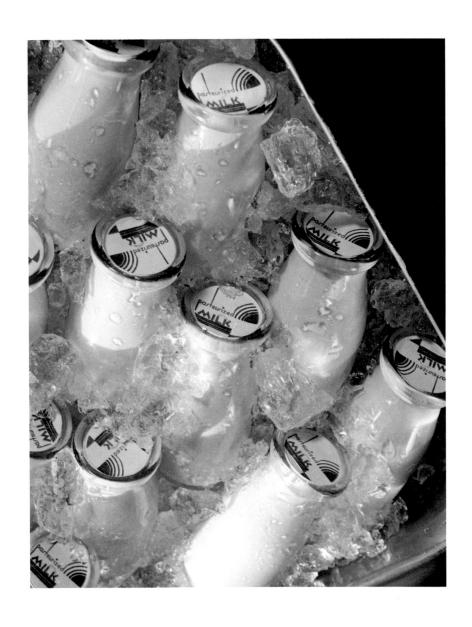

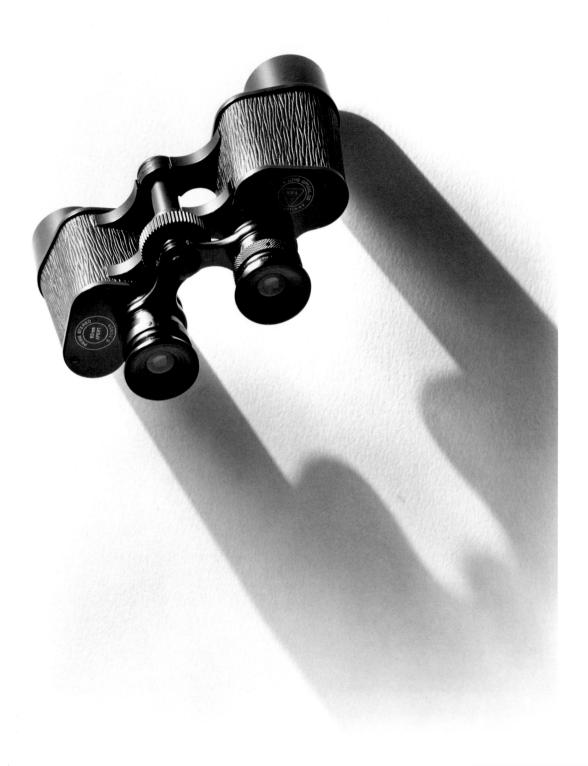

John F. Collins AMERICAN, 1888–1990
Bausch and Lomb Binoculars, 1927 Gelatin silver print

Checklist of the Exhibition

Berenice Abbott
AMERICAN, 1898–1991
New York at Night, Empire State Building, 350 Fifth Avenue, West Side, 34th and 33rd Streets (General View North), Manhattan, c. 1932
Gelatin silver print

Edward Alenius
AMERICAN, BORN IN FINLAND, 1892–1990
Business Relatives, c. 1930
Gelatin silver print

Theo Ballmer
SWISS, 1902–1964
Study: Cube on Wood, 1929–1932
Gelatin silver print

Herbert Bayer
AMERICAN, BORN IN AUSTRIA, 1900–1986
[New York City, skywriter], 1937
Gelatin silver print

Herbert Bayer
AMERICAN, BORN IN AUSTRIA, 1900–1986
Sforza Castle, Milan, 1945
Gelatin silver print

Hans Bellmer
FRENCH, BORN IN KATOWICE, SILESIA (NOW IN POLAND), 1902–1975
The Doll, 1934
Gelatin silver print with paint

Mieczyslaw Berman
POLISH, 1903–1975
Untitled [Construction], 1929
Gelatin silver print with paint

Ilse Bing
AMERICAN, BORN IN GERMANY, 1899
Street Cleaner and Two Men, 14th Arrondissement, Paris, 1947
Gelatin silver print

Ilse Bing
AMERICAN, BORN IN GERMANY, 1899
Poster for "The Private Life of Henry VIII," Paris, 1934
Gelatin silver print

A. Aubrey Bodine
AMERICAN, 1906–1970
Hats, 1923–1927
Gelatin silver print

Renata Bracksieck
GERMAN
Mannequins, c. 1929–1932
Gelatin silver print

Brassaï (Gyula Halàsz)
FRENCH, BORN IN BRASOV, TRANSYLVANIA (NOW IN ROMANIA), 1899–1984
Street Scene, Paris, 1930–1939
Gelatin silver print

Francis Bruguière
AMERICAN, 1879–1945
Cut Paper Abstraction, c. 1927
Gelatin silver print

Esther Bubley
AMERICAN, BORN 1921
Signs on Chestnut Street, Virginia, Minnesota, 1947
Gelatin silver print

Hans Casparius
GERMAN, 1900–1986
Untitled [Shadows on steps], c. 1930
Gelatin silver print

John F. Collins
AMERICAN, 1888–1990
Bausch and Lomb Binoculars, 1927
Gelatin silver print

John F. Collins
AMERICAN, 1888–1990
Glasses and Case (Shur-On Optical), c. 1929
Gelatin silver print

Carlotta Corpron
AMERICAN, 1901–1988
Dowagers at Modern Sculpture Exhibit (Fun with Distortion), c. 1948
Gelatin silver print

Harold Halliday Costain
AMERICAN, 1897–1994
Eel-Skid Oil, c. 1936
Gelatin silver print

Gordon Coster
AMERICAN, 1906–1988
Montage for Heating Company, c. 1930
Gelatin silver print

Konrad Cramer
AMERICAN, BORN IN GERMANY, 1883–1963
Pipes, c. 1940
Gelatin silver print

George Daniell
AMERICAN, BORN 1911
Construction of the George Washington Bridge, New York City, 1938
Gelatin silver print

Jack Delano
AMERICAN, BORN IN RUSSIA, 1914
Painting on a Barn near Thomasonville, along Route 5, Connecticut, 1940
Gelatin silver print

Frantisek Drtikol
CZECH, 1883–1961
Untitled [Figures on a staircase], 1911
Pigment print

Arnold Eagle
AMERICAN, 1909–1992
New York [skyline and El tracks], 1935
Gelatin silver print

Josef Ehm
CZECH, 1909–1989
Cacti and Rocks, 1934–1946
Gelatin silver print

Walker Evans
AMERICAN, 1903–1975
[Prisoners working beside a road], 1936
Gelatin silver print

Walker Evans
AMERICAN, 1903–1975
Torn Minstrel Poster, Demopolis, Alabama, 1936
Gelatin silver print

T. Lux Feininger
AMERICAN, BORN IN GERMANY, 1910
New York, 1948
Gelatin silver print

Werner David Feist
GERMAN, BORN 1909
Water Tap on Bauhaus Wall, Dessau, 1929
Gelatin silver print

Henry Flannery
AMERICAN, ACTIVE 1930S
Backgammon, c. 1930
Gelatin silver print

Jaromir Funke
CZECH, 1896–1945
From the Cycle "Time Persists," 1932
Gelatin silver print

Jaromir Funke
CZECH, 1896–1945
Untitled [Photogram], 1927–1929
Gelatin silver print

George Grosz
GERMAN, 1893–1959
[Boy filling beer mug], c. 1920
Collage

Rosalie Gwathmey
AMERICAN, BORN 1908
Paris [woman walking by wall of posters], 1949
Gelatin silver print

Miroslav Hák
CZECH, 1911–1978
Mask, 1938
Gelatin silver print

Miroslav Hák
CZECH, 1911–1978
Portrait of Franz Grosse, mid-1930s
Gelatin silver print

Raoul Hausmann
FRENCH, BORN IN AUSTRIA, 1886–1971
Photogram, 1931
Gelatin silver print

John Havinden
BRITISH, 1908–1957
Untitled [Christmas ornaments in storage], 1932–1939
Gelatin silver print

John Havinden
BRITISH, 1908–1957
Fire Escape, 1932–1939
Gelatin silver print

John Havinden
BRITISH, 1908–1957
Men's Underwear, 1932–1939
Gelatin silver print

John Havinden
BRITISH, 1908–1957
Abstraction [detail of fabric], 1932–1939
Gelatin silver print

Henryk Hermanowicz
POLISH, BORN 1912
Woman with Closed Eyes, 1937
Gelatin silver print

Kati Horna
MEXICAN, BORN IN SPAIN, 1912
Untitled [Barcelona], 1937
Gelatin silver print

Lotte Jacobi
AMERICAN, BORN IN GERMANY,
1896–1990
Russian Workers, 1932–1933
Gelatin silver print

Edmund Kesting
GERMAN, 1892–1970
Untitled [Profile and lace], 1933–1935
Gelatin silver print

R. Koch
POSSIBLY AMERICAN, 1889–1971
Sculpture, probably by K. Schwerdt-feger, c. 1930
Gelatin silver print

Juro Kubicek
GERMAN, BORN IN GOERLITZ (NOW IN
POLAND), 1906–1970
Anatomical figure, 1947
Collage

Dorothea Lange
AMERICAN, 1895–1965
*Unemployment Benefits Aid Begins.
Line of Men inside Division Office of
State Employment Service Office,
San Francisco*, 1938
Gelatin silver print

Clarence John Laughlin
AMERICAN, 1905–1985
The Autonomous Spiral, 1949
Gelatin silver print

Russell Lee
AMERICAN, 1903–1986
*Interior of Grocery Store, Funkley,
Minnesota*, c. 1937
Gelatin silver print

Russell Lee
AMERICAN, 1903–1986
*North Dakota Farm Woman Listening
to Radio*, c. 1937
Gelatin silver print

Herbert List
GERMAN, 1903–1975
Rue de Rivoli, Paris, 1936 or later
Gelatin silver print

Mannie Lovitch
AMERICAN
Out of Mesh, 1920s
Gelatin silver print

Dorothy Luckie
AMERICAN, ACTIVE 1930S
The Hook, 1939
Gelatin silver print

Werner Mantz
GERMAN, 1901–1983
Factory, 1937
Gelatin silver print

Erich Mrozek
GERMAN, BORN 1910
*Untitled [Still life with paint tubes and
printers' type]*, c. 1929–1931
Gelatin silver print

Pierre Nobel
FRENCH?
*Untitled [Sculpture, probably by John
Storrs]*, 1920s
Gelatin silver print

Gordon Parks
AMERICAN, BORN 1912
*Contents of an Army Supper K-Ration
Unit, Used by Soldiers on the Fighting
Front*, 1945
Gelatin silver print

Charles Pratt
AMERICAN, 1926–1976
Hoboken Ferry, 1955
Gelatin silver print

Edward Quigley
AMERICAN, 1898–1977
Milk on Ice, c. 1930
Gelatin silver print

Man Ray (Emmanuel Rudnitsky)
AMERICAN, 1890–1976
Empire State Building, 1936
Gelatin silver print

Man Ray (Emmanuel Rudnitsky)
AMERICAN, 1890–1976
*Rayograph: Mathematical Object. A
Plane Bitangent to a Torus, the Cut
Following Two Circles (Villarceau's
Theorem)*, 1936
Gelatin silver print

Vilem Reichmann
CZECH, 1908–1991
UNIKAT!, 1940
Gelatin silver print

Albert Renger-Patzsch
GERMAN, 1897–1966
Gears, c. 1929
Gelatin silver print

Albert Renger-Patzsch
GERMAN, 1897–1966
Detail [grater], c. 1929
Gelatin silver print

Albert Renger-Patzsch
GERMAN, 1897–1966
Hook, c. 1929
Gelatin silver print

Wynn Richards (Martha Wynn)
AMERICAN, 1888–1960
Matches, c. 1922
Gelatin silver print

Wynn Richards (Martha Wynn)
AMERICAN, 1888–1960
Collander and Spoons, c. 1918
Gelatin silver print

William Rittase
AMERICAN, 1887–1968
Smokestacks, c. 1940
Gelatin silver print

William Rittase
AMERICAN, 1887–1968
St. Joseph Lead Company, c. 1940
Gelatin silver print

William Rittase
AMERICAN, 1887–1968
Romance of Machinery, 1930s
Gelatin silver print

William Rittase
AMERICAN, 1887–1968
[Train crossing bridge], 1930s
Gelatin silver print

Werner Rohde
GERMAN, 1890–1963
Pit & Renata [Ellen Auerbach and Renata Bracksieck], c. 1933
Gelatin silver print

Edwin & Louise Rosskam
AMERICAN, BORN IN GERMANY, 1903–1985
AND AMERICAN, BORN 1910
Main Street, Cody, Wyoming, 1940–1945
Gelatin silver print

Jaroslav Rossler
CZECH, BORN 1902
Paris, 1933
Gelatin silver print

Theodore Roszak
AMERICAN, BORN IN POSEN, PRUSSIA (NOW IN POLAND), 1907–1981
Photogram, 1937–1941
Gelatin silver print

Arthur Rothstein
AMERICAN, 1915–1985
Restaurant Sign, Monte Rose, Colorado, 1939
Gelatin silver print

Ben Schnall
AMERICAN, BORN IN EUROPE (?), ACTIVE 1930s–1940s

Film Reels, 1938–1941
Gelatin silver print

Ben Shahn
AMERICAN, BORN IN LITHUANIA, 1898–1969
Housewife, Small Town, Ohio, 1935–1938
Gelatin silver print

Arthur Siegel
AMERICAN, 1913–1978
Photogram, 1937
Gelatin silver print

Carl Struwe
GERMAN, 1898–1988
The Structure of Human Bone Marrow, from "Forms of the Microcosm," before 1955
Gelatin silver print

Josef Sudek
CZECH, 1896–1976
Cups and Saucers, 1928–1936
Gelatin silver print

Josef Sudek
CZECH, 1896–1976
[Street scene], 1924–1926
Gelatin silver print

Edmund Teske
AMERICAN, 1911–1995
Chicago [Mannequins], 1938
Gelatin silver print

Else Thalemann
GERMAN, 1901–1984
Machine Detail, c. 1930
Gelatin silver print

Else Thalemann
GERMAN, 1901–1984
Fresh from the Shoe Maker, c. 1932
Gelatin silver print

Walter Tralau
GERMAN, BAUHAUS STUDENT DURING THE
1920S
*Assignment for László Moholy-Nagy's
Preliminary Course at the Bauhaus,*
c. 1926–1927
Gelatin silver print

Georg Trump
GERMAN, 1896–1985
Orange and Shadow, 1926–1931
Gelatin silver print

Lloyd Ullberg
AMERICAN, 1904–1996
Pulleys, Philadelphia, c. 1932
Gelatin silver print

Underwood and Underwood
AMERICAN FIRM, ACTIVE 1880S–1940S
B&O Bus Station, n.d.
Gelatin silver print

Unidentified
[Tracks], 1930s?
Gelatin silver print

Unidentified
*Douglas Fairbanks Film Premiere,
Grauman's Chinese Theater, Holly-
wood,* 1928 or 1929
Gelatin silver print

John Vachon
AMERICAN, 1914–1975
Advertising, Woodbine, Iowa, 1940
Gelatin silver print

Eugen Wiskovsky
CZECH, 1888–1964
*Rolator S. Pruzinov (Isolater and
Spring),* 1935
Gelatin silver print

Marion Post Wolcott
AMERICAN, 1910–1990
*Mrs. Rosa Wilkins Making Biscuits,
Granville County, North Carolina,* 1939
Gelatin silver print

Estelle Wolf
AMERICAN, 1886–1988
Non Sequitur, 1932
Gelatin silver print

Lloyd Yost
AMERICAN, ACTIVE 1920S–1930S
The First Day Club, 1930 or earlier
Gelatin silver print

Piet Zwart
DUTCH, 1885–1977
Hose, 1930
Gelatin silver print

Piet Zwart
DUTCH, 1885–1977
Sports, c. 1932
Gelatin silver print

Acknowledgments

This exhibition and publication are the result of much work and dedication by many people. The project originated in discussions between Joyce Cowin and Willis Hartshorn, Charles Stainback and Miles Barth of the International Center of Photography, and all of them have participated in shaping its final form. Joyce Cowin has been unfailingly gracious and supportive during all stages of the undertaking, and her daughter Dana Cowin has also been generous with her time and encouragement.

Much invaluable work on this project was done by Robyn Hollingshead and Judith Czernichow, interns at ICP, and Mary Vahey of the Exhibitions Department. Research for this project depended heavily upon the generosity and expertise of many museum colleagues, art dealers, scholars and photographers, who are too numerous to mention individually. Without them, our documentation of the works in this exhibition would have been sadly incomplete. Steve Stinehour, Brennan Colby and Jerry Kelly of The Stinehour Press have worked wonders in bringing this volume into being, and we are especially indebted to Jerry Kelly for his knowledge of Bauhaus graphic design and typology. Cathy Peck, the editor for this publication, brought to her task great tact and expertise. Our sincere thanks go to each of these people, and to all the others who have helped to produce this exhibition and book.

E. H.